GRUNGE ALPHABETS

GRUNGE ALPHABETS

100 Complete Fonts

Selected and Arranged by

DAN X. SOLO

from the
Solotype Typographers Catalog

DOVER PUBLICATIONS, INC.
Mineola, New York

Bibliographical Note

Grunge Alphabets: 100 Complete Fonts is a new work, first published by Dover Publications, Inc., in 1998.

DOVER *Pictorial Archive* SERIES

This book belongs to the Dover Pictorial Archive Series. You may use the letters for graphics and crafts applications, free and without special permission, provided that you include no more than six words composed from them in the same publication or project. (For any more extensive use, write directly to Solotype Typographers, 298 Crestmont Drive, Oakland, California 94619, who have the facilities to typeset extensively in varying sizes and according to specifications.)
However, republication or reproduction of any letters by any other graphic service, whether it be in a book or in any other design resource, is strictly prohibited.

Library of Congress Cataloging-in-Publication Data

Grunge alphabets : 100 complete fonts / selected and arranged by Dan X. Solo from the
 Solotype Typographers catalog.
 p. cm. — (Dover pictorial archive series)
 ISBN 0-486-40282-7 (pbk.)
 1. Display type. 2. Printing—Specimens. 3. Alphabets. I. Solo, Dan X. II.
 Solotype Typographers. III. Series.
 Z250.5.D57G78 1998
 686.2'24—dc21 98-38752
 CIP

Manufactured in the United States of America
Dover Publications, Inc., 31 East 2nd Street, Mineola, N.Y. 11501

ASPODISTRA

ABCDEFGHIJ
KLMNOPQR
STUVWXYZ

abcdefghijk
lmnopqrst
uvwxyz
1234567890

Badman

A B C D E F
G H I J K L M
N O P Q R S T
U V W X Y Z
(& ; ! ?)
a b c d e f g h i
j k l m n o p q r
s t u v w x y z
9 1 2 3 4 5 6 7
8 9 0

Blotter Roman

ABCDEFGHI
JKLMNOPQR
STUVWXYZ

!.;?

abcdefghijklmn
opqrstuvwxyz

$1234567890

Bramble

ABCDEFGHI
JKLMNOPQR
STUVWXYZ
(&;!?)

abcdefghijkl
mnopqrst
uvwxyz

$1234567890

BUSHMAN

ABCDEFGHI
JKLMNOP
QRSTUV
WXYZ
(&;!?)

$1234567890

CHARLIE HORSE

ABCDEFG
HIJKLMNOP
QRSTUV
WXYZ
(&;!?)

$1234567890

COLLAGE

ABCDEFG
HIJKLMNO
PQRSTUV
WXYZ
(&;!?)

$1234567890

Crazy Daisy

ABCDEFGHI
JKLMNOPQR
STUVWXYZ

&

abcdefghijklm
nopqrstuv
wxyz

crumbles

ABCDEFGHIJK
LMNOPQRSTUV
WXYZ
(&;!?)
abcdefghijklm
nopqrstuvwxyz

$1234567890

DAY & NIGHT ONE

ABCDEFG
HIJKLMNOP
QRSTUV
WXYZ
&;!?$
1234567890

DAY & NIGHT TWO

ABCDEFG
HIJKLMNOP
QRSTUV
WXYZ
&;!?$
1234567890

Degraded Medium

ABCDEFGHIJKL
MNOPQRSTUVW
XYZ&!

abcdefghijklmnop
qrstuvwxyz

1234567890

DESERT RAT

ABCDEFGHI
JKLMNOPQR
STUVWXYZ
(&,.!?)

$1234567890

DEVICE

ABCDEFGHIJKLM

NOPQRSTUVW

XYZ

(&;!?)

$1234567890

DR. MUMBLES

ABCDEFG
HIJKLMN
OPQRST
UVWXYZ
(&;!?)

$1234567890

Double Take

ABCDEFGHI
JKLMNOPQR
STUVWXYZ
(&;!?)
abcdefghijklmno
pqrstuvwxyz
$1234567890

Dropout

ABCDEFGHIJK
LMNOPQRST
UVWXYZ
(&;!?)

abcdefghijklmn
opqrstuvwxyz

$1234567890

Dry Brush Gothic

ABCDEFGH
IJKLMNOP
QRSTUVWX
YZ

abcdefghij
klmnopqrs
tuvwxyz

1234567890

18

EVERGLADES

ABCDEFG

HIJKLMNOP

QRSTUV

WXYZ

&!?

$1234567890

Fan Club Bold

ABCDEFGHI
JKLMNOPQR
STUVWXYZ
(&;!?)
abcdefghijklmn
opqrstuvwxyz

$1234567890

Fan Club Shaded

ABCDEFGHI
JKLMNOPQR
STUVWXYZ
(&;!?)
abcdefghijklm
nopqrstuv
wxyz
$1234567890

FINGERPAINT

ABCDEF

GHIJKL

MNOPQRS

TUVW

XYZ

!;?

Foley Dancer

ABCDEFGHI
JKLMNOPQR
STUVWXYZ
&,!?

abcdefg
hijklmnopq
rstuvwxyz

$1234567890

FriendlyFred

ABCDEFGHIJKL
MNOPQRSTUV
WXYZ
(&,!?)

ABCDEFGHIJKLM
NOPQRSTUVWXYZ

$1234567890

Genius Script

ABCDEFGHI
JKLMNOPQ
RSTUVWXYZ
(and..!?)
abcdeFghijklmn
opqrstuvwxyz
1234567890

GERALD

ABCDEFG
HIJKLMNO
PQRSTUV
WXYZ
!.,?
$1234567890

GINZA

ABCDEFG
HIJKLMN
OPQRSTU
VWXYZ
!,?

1234567890

GLUG

ABCDEFG
HIJKLMN
OPQRST
UVWXYZ

Gooseflesh

ABCDEFG
HIJKLMNOP
QRSTUVW
XYZ &;!?
abcdefghijklmn
opqrstuvwxyz

$1234567890

GRAB BAG

A B C D E F
G H I J K L M N
O P Q R S T
U V W X Y Z Z
? : ! $
1 2 3 4 5
6 7 8 9 0

Grey Cloud

ABCDEFGHI
JKLMNOPQR
STUVWXYZ
(&!;?)
abcdefghi
jklmnopqrs
tuvwxyz
1234567890

Grumble

A B C D E F G
H I J K L M N
O P Q R S T
U V W X Y Z

(& : ! ?)

a b c d e f g h i j k l m n o p
q r s t u v w x y z

$ 1 2 3 4 5 6 7 8 9 0

Hallum

ABCDEFGHIJ

KLMNOPQRST

UVWXYZ

(&,!?)

abcdefghijkl

mnopqrst

uvwxyz

$1234567890

Hardscrabble

ABCDEFG
HIJKLMNOPQR
STUVWXYZ
(&;!?)

abcdefghijklmn
opqrstuvwxyz
$1234567890

Heckler Lightweight

ABCDEFGHI

JKLMNOPQ

RSTUVWXYZ

(&;!?)

#1234567890

Hot Diggity

ABCDEFGHIJ

KLMNOPQR

STUVWXYZ

(&;!?)

abcdefghijkl

mnopqrstu

vwxyz

$1234567890

Hurricane

ABCDEFGHIJ
KLMNOPQRST
UVWXYZ

(&;!?)

abcdefghijklmno
pqrstuvwxyz

$1234567890

INKJET

ABCDEFGHI
JKLMNOPQR
STUVWXYZ

&:!?

#1234567890

KEENCUT

ABCDEFG
HIJKLM
NOPQR
STUVW
XYZ

kidprint

ABCDEFGHI
JKLMNOPQRS
TUVWXYZ
(&;!?)
abcdefghijkl
mnopqrstu
vwxyz

$1234567890

LAPHAM SCRAWL

ABCDEFG
HIJKLMN
OPQRST
VVWXYZ
(&;!?)

1234567890

La Ultima One

ABCDEFGHIJKL

MNOPQRST

UVWXYZ

[&;!?]

abcdefghijklmno

pqrstuvwxyz

$1234567890

La Ultima Two

ABCDEFGHIJKL
MNOPQRST
UVWXYZ
(&;!?)
abcdefghijklmno
pqrstuvwxyz

$1234567890

La Ultima Three

ABCDEFGHIJKL
MNOPQRST
UVWXYZ
(&;!?)
abcdefghijklmno
pqrstuvwxyz

$1234567890

LAYOUT GOTHIC

ABCDEFGH
IJKLMNOP
QRSTUVW
XYZ
&!?
$1234567
890

LITTLE SHEEBA

ABCDEFGHI
JKLMNOP
QRSTUVW
XYZ
&!,?$

1234567890

Live Wire

ABCDEFG
HIJKLMNO
PQRSTUV
WXYZ
(&,!?)

abcdefghijklm
nopqrstuv
wxyz

1234567890

Loveletter

ABCDEFGHIJ
KLMNOPQRS
TUVWXYZ
(&;!?)
abcdefghij
klmnopqrst
uvwxyz

$1234567890

Meſſenger

ABCDEFGHIJKL
MNOPQRST
VWWXYZ
(&;!?)
abcdefghijklmnop
qrſtuvwxyz

$1234567890

Miss Muffet

ABCDEFGHI
JKLMNOPQRS
TUVWXYZ
(&;!?)

1234567890

Mongrel

ABCDEFGHI
JKLMNOPQR
STUVWXYZ
(&!?)
abcdefghijklmn
opqrstuvwxyz

$1234567890

MOUNTAIN BLOCK

ABCDEF

GHIJKL

MNOPQR

STUVW

XYZ

Mountain Cabin

ABCDEFGHI
JKLMNOPQ
RSTUVWXYZ
(&;!?)
abcDefghij
KLMNOpqrst
uvwxyz
1234567890

MUDDY WATER

ABCDEFGHI
JKLMNOP
QRSTUV
WXYZ
&;!?

$1234567890

NAVAJO *

ABCDEFG
HIJKLM
NOPQRST
UVWXYZ
(&;!?)
$1234567
890

Nervous Nellie

ABCDEFGHIJKL
MNOPQRSTU
VWXYZ

(&;!?)

abcdefghijklmnop
qrstuvwxyz

$1234567890

NIGHTSTALKER

ABCDEFG
HIJKLMNO
PQRSTUV
WXYZ&;!?
1234567
890

NIGHTSTALKER CONDENSED

ABCDEFGHIJ
KLMNOP
QRSTUVW
XYZ&;!?

$1234567890

NINJA

ABCDEF
GHIJKL
MNOPQR
STUVW
XYZ&!?

1234567890

Nirvana

ABCDEFGHI
JKLMNOPQR
STUVWXYZ
(&;!?)
abcdefghijkl
mnopqrst
uvwxyz

$1234567890

North Beach

ABCDEFGHIJ
KLMNOPQRST
UVWXYZ
(&;!?)
abcdefghijklm
nopqrstuvwxyz

$1234567890

OOLA BOOLA

ABCDEFG
HIJKLMN
OPQRSTU
VWXYZ
(&!?)

1234567890

Oompah

ABCDEFGHIJ
KLMNOPQR
STUVWXYZ

(&;!?)

abcdefghijkl
mnopqrst
uvwxyz

1234567890

Pelham Bold

ABCDEFG
HIJKLMNO
PQRSTUV
WXYZ&¡!?
abcdeEghijklm
noparsTuv
wxyz

$1234567890

Pencling

ABCDEFGHI
JKLMNOPQRS
TUVWXYZ
(&;!?)

abcdefghijklmn
opqrsttuvwxyz

$1234567890

PLAYSCHOOL

ABCDEFG
HIJKLMM
OPQRST
UVWXYZ
(&;!?$)
12345678
90

Potters Field Bold

ABCDEFGHIJ
KLMNOPQRST
UVWXYZ

(&;!?)

abcdefghijklmno
pqrstuvwxyz

$1234567890

Potters Field Light

ABCDEFGHIJ
KLMNOPQRST
UVWXYZ

(&;!?)

abcdefghijklmno
pqrstuvwxyz

$1234567890

PUCK

ABCDEFGHIJK
LMNOPQRST
UVWXYZ
(&;!?)

$1234567890

Radical Shaded

ABCDEFGHI
JKLMNOPQR
STUVWXYZ
&
abcdefghijklm
nopqrstuv
wxyz

RANSOM NOTE

A A B C D E e E E F f G

H H I i J K L l M M N N

O O O P Q R R S S S

t T T U U V W X Y Z

& ! ?

$ 1 1 2 2 3 3 4 4 5 5 6

7 8 8 9 9 0 0

RaNSOM NOte REVeRSE

A a B C D E e f F G g

H i J K L L M N N O

P P Q R R S S S T t

U V w W X Y y Z

& ! ?

$ 1 2 3 4 4 5 6 7

8 8 9 g 0 0

Red Dog

ABCDEF
GHIJKLM
NOPQRST
UVWXYZ
(& ; ! ?)
abcdefghi
jklmnopqr
stuvwxyz
$1234567
890

Rowdy

ABCDEFGHIJ
KLMNOPQRST
UVWXYZ

(&;!?)

abcdefghijklmno
pqrstuvwxyz
$1234567890

Rumpled Roman

ABCDEFGHIJK
LMNOPQRSTUV
WXYZ;!?&

abcdefghijklmnn
opqrstuvwxyz

$1234567890

Sandstorm

ABCDEFGHI
JKLMNOPQRST
UVWXYZ

(&;!?)

abcdefghijklmno
pqrstuvwxyz

$1234567890

SAZARAC

ABCDEFGH
IJKLMNOP
QRSTUVW
XYZ
(&;!?)

$1234567890

Scratch

ABCDEFG
HIJKLMNO
PQRSTUV
WXYZ
(!?)

$123456789O

SLAUGHTER

ABCDEFG

HIJKLMN

OPQRSTU

VWXYZ

SLAUGHTER SHADED

ABCDEFG

HIJKLMN

OPQRSTU

VWXYZ

SPARKS

ABCDEFGH
IJKLMNOP
QRSSTUV
WXYZ
&!?

$1234567
890

Spatter

ABCDEFGHIJK
LMNOPQRSTU
VWXYZ
(&;!?)
abcdefghijklmno
pqrstuvwxyz
$1234567890

Sweetheart

ABCDEFGH
IJKLMNOP
QRSTUV
WXYZ
!;?
abcdefghijklmno
pqrstuvwxyz

1234567890

Technique

ABCDEFGHI
JKLMNOPQR
STUVWXYZ
(&;!!2)
abcdefghijklm
nopqrstuvwxyz
$1234567890

THATCHER BOLD

ABCDEFGHI
JKLMNOPQR
STUVWXYZ
(&!?)

$1234567890

THATCHER LIGHT

ABCDEFGHI
JKLMNOPQR
STUVWXYZ

(&.!?)

$1234567890

Threadneedle

ABCDEFGHIJ
KLMNOPQRST
UVWXYZ

(&;!?)

abcdefghijklm
nopqrstuv
wxyz

$1234567890

TIME CAPSULE

ABCDEFG
HIJKLMNO
PQRSTUV
WXYZ
(&;!?$)

1234567890

Trapeze

ABCDEFGHIJ
KLMNOPQRST
UVWXYZ

(& ; ! ?)

abcdefghijklmn
opqrstuvwxyz

$1234567890

TRIBBLE

ABCDEFGHI
JKLMNOPQR
STUVWXYZ
(&,!?)
ABCDEFGHI
JKLMNOPQR
STUVWXYZ
$1234567890

Underwood

ABCDEFGHIJK
LMNOPQRST
UVWXYZ
(& ; ! ?)
abcdefghijkl
mnopqrstuv
wxyz

$1234567890

Turbulance

ABCDEFGHIJ
KLMNOPQRST
UVWXYZ
(&!;?)
abcdefghijkl
mnopqrstuv
wxyz
$1234567890

versatile Script

ABCDEFGHIJ
KLMNOPQRS
TUVWXYZ
(&;!?)
abcdefghijklmnop
qrstuvwxyz
$1234567890

violet script

abcdefgh
ijklmnop
qrstuvw
xyz
(&;!?)

$1234567890

Warehouse Gothic

ABCDEFGH
IJKLMNOPQ
RSTUVW
XYZ&!?

abcdefghijklm
nopqrstuv
wxyz
1234567890

Watermark

ABCDEFGHIJK
LMNOPQRST
UVWXYZ

abcdefghijklmn
opqrstuvwxyz

WHISKEY FLAT

ABCDEFGH
IJKLMNOPQRS
STUVWXYZ

(&;!?$)

1234567890

WILDSIDE TWO

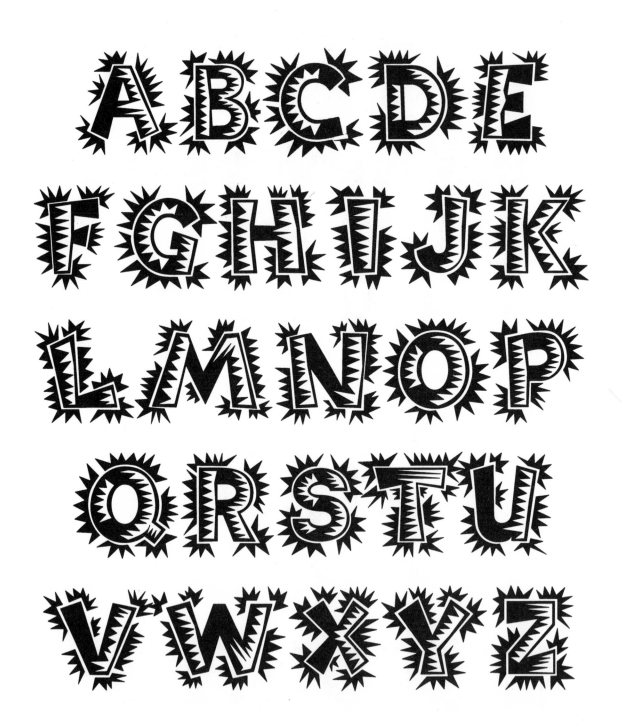

A B C D E
F G H I J K
L M N O P
Q R S T U
V W X Y Z

Wishing Well Light

ABCDEFGHIJK
LMNOPQRST
UVWXYZ
(&;!?)
abcdefghijklmno
pqrstuvwxyz

$1234567890

YANKEE GO HOME

ABCDEFG
HIJKLMNO
PQRSTUV
WXYZ
(&;!?)

$1234567890